YOU CAN DRAW FANTASY FIGURES
DRAWING BEASTLY BEINGS

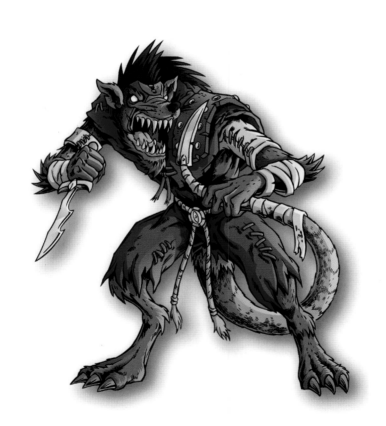

BY STEVE SIMS

Gareth Stevens
Publishing

Please visit our Web site, www.garethstevens.com. For a free color catalog of all our high-quality books, call toll free 1-800-542-2595 or fax 1-877-542-2596.

Library of Congress Cataloging-in-Publication Data

Sims, Steve (Steve P.), 1980-
Drawing beastly beings / Steve Sims.
 p. cm. – (You can draw fantasy figures)
Includes index.
ISBN 978-1-4339-4055-2 (library binding
ISBN 978-1-4339-4056-9 (pbk.)
ISBN 978-1-4339-4057-6 (6-pack)
1. Fantasy in art. 2. Grotesque in art. 3. Drawing–Technique.
I. Title.
NC825.F25S559 2010
743'.87–dc22

 2010015838

First Edition

Published in 2011 by
Gareth Stevens Publishing
111 East 14th Street, Suite 349
New York, NY 10003

Copyright © 2011 Arcturus Publishing

Artwork and Text: Steve Sims
Editors: Kate Overy and Joe Harris
Designer: Steve Flight

Printed in the United States of America

CPSIA compliance information: Batch #AS10GS: For further information contact Gareth Stevens, New York, New York at 1-800-542-2595.

SL001638US

CONTENTS

Drawing and Inking Tips

In the world of swords and sorcery, heroes can perform extraordinary feats of valor that would be impossible in the real world. However, it's still essential that your characters should look solid and believable. So here are some helpful hints to keep in mind.

1 First, work out your character's posture and attitude using a wire frame. You can look in the mirror to work out how a pose might work!

2 Build on your frame using basic shapes such as cylinders and spheres. As you add them to your wire frame, you can start to see your figure taking shape. From there, draw a smooth outline around the shapes to flesh out your figure.

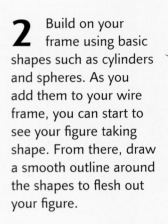

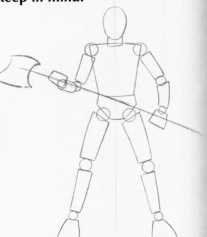

TOP TIP !

Most adult human figures are seven times the height of their head. Draw your character's head, then calculate his or her height by measuring three heads for the legs, one for the lower torso, and two for the upper body.

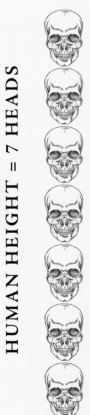

HUMAN HEIGHT = 7 HEADS

3 When things are looking good and your character is complete, you can start to ink the picture. Inking allows us to choose the best lines we have drawn in pencil and make them stand out from the rest.

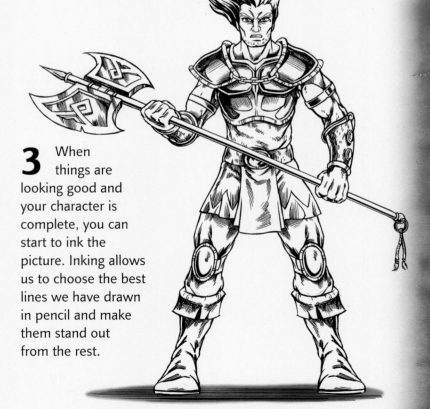

4

Coloring Tips

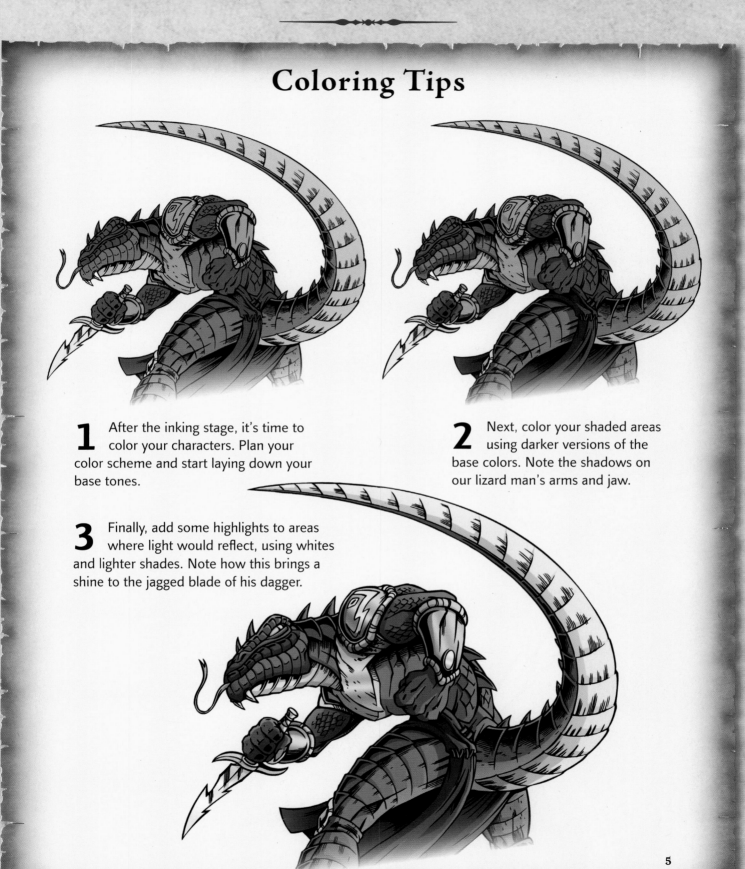

1 After the inking stage, it's time to color your characters. Plan your color scheme and start laying down your base tones.

2 Next, color your shaded areas using darker versions of the base colors. Note the shadows on our lizard man's arms and jaw.

3 Finally, add some highlights to areas where light would reflect, using whites and lighter shades. Note how this brings a shine to the jagged blade of his dagger.

RAT WARRIOR

From the shadowy rubble of ruined cities and long-abandoned kingdoms spew hordes of deadly rat warriors. Charging forth with wild eyes and ravenous jaws, they are ready to ambush and destroy any travelers who stray too close to their territory.

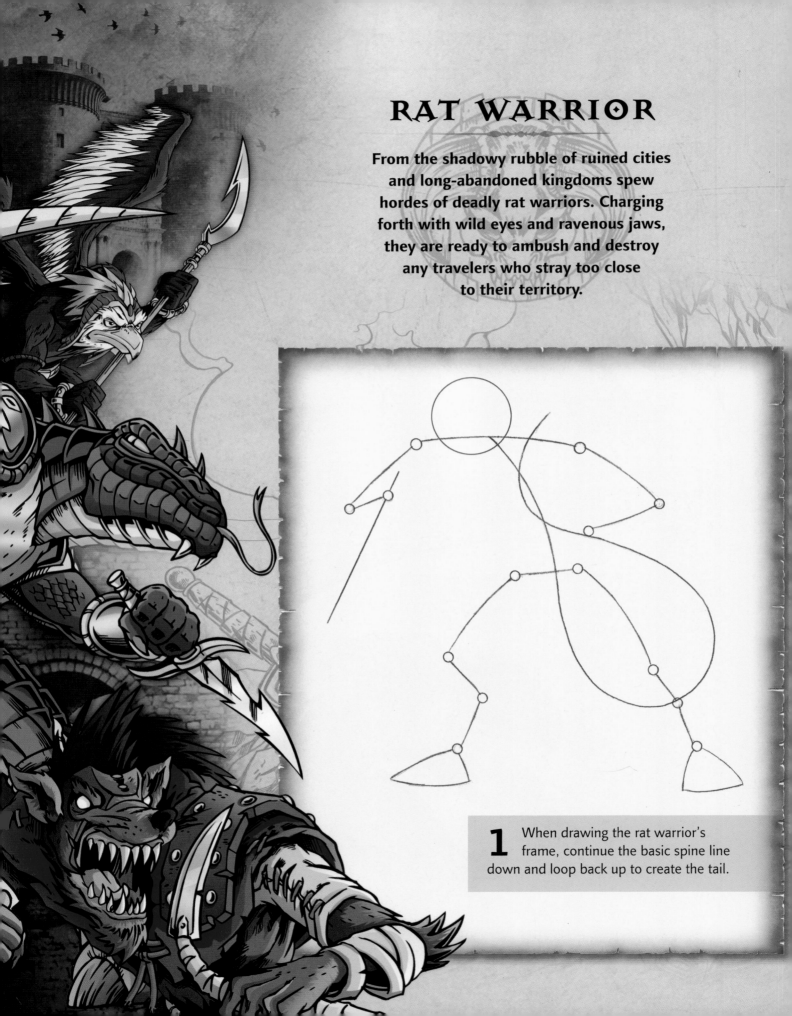

1 When drawing the rat warrior's frame, continue the basic spine line down and loop back up to create the tail.

2 Build on your frame using basic shapes and start to fill out your figure, marking in the torso, tail, and snout. Erase your frame lines when you're happy with how he's shaping up.

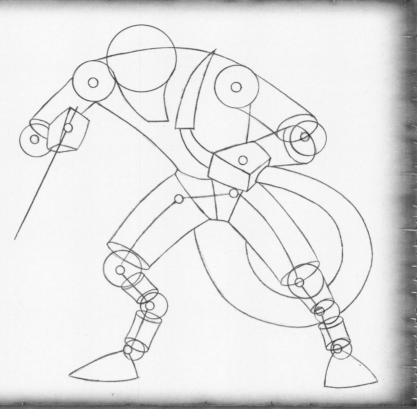

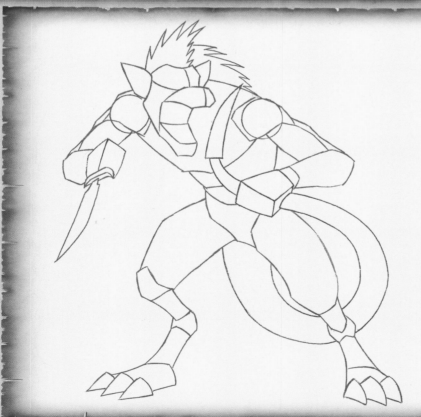

3 Start to define the body a bit more to create a smooth outline. The rat warrior has a long snout—you can add detail to it later. Draw in the hair and ears, then pencil in his weapons.

7

4 Erase all of your basic shapes and lines to leave a clean pencil drawing that's ready for detail. Draw his ragged clothing, tufts of fur, and his facial features—including a set of razor-sharp teeth!

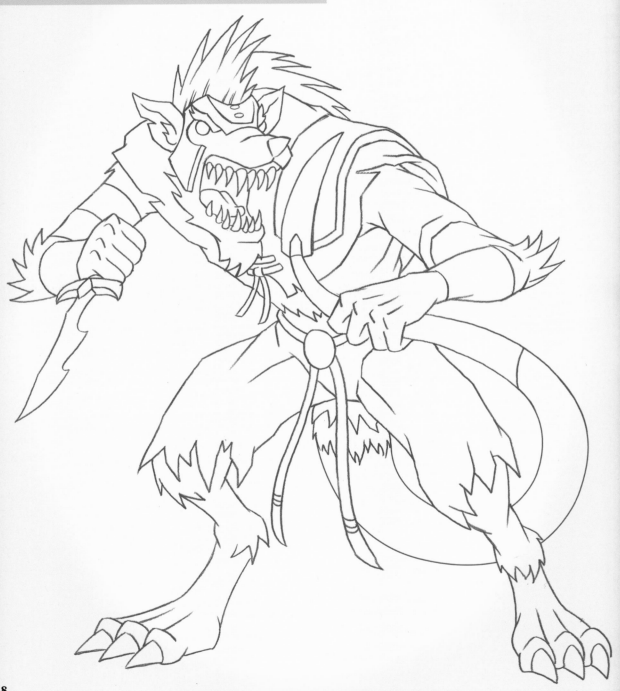

5 When adding the fine detail, develop his tattered clothing by adding lots of rips and tears. Leave his eyes pupil-free to give him an unearthly look. Add texture to the fur and start shading.

TOP TIP !

Try experimenting with the balance of animal and human characteristics. The rat warrior's stance and body shape are his human qualities.

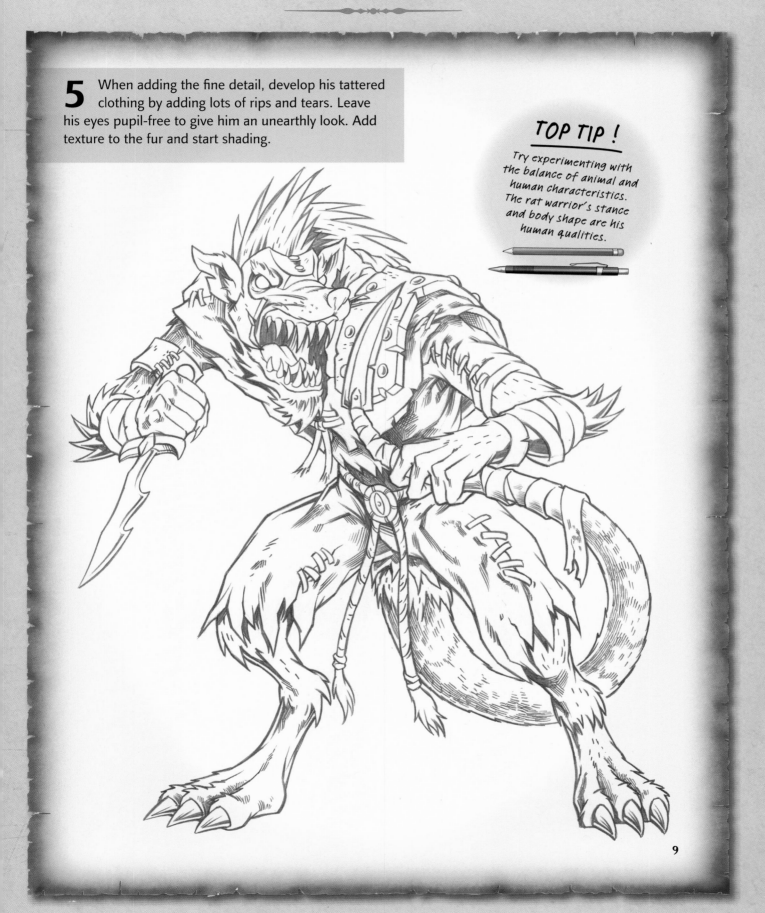

6 Now it's time to ink your rat warrior. Use delicate lines for the texture of his tail and the marks on his clothing. Apply heavy black ink to the areas in shade.

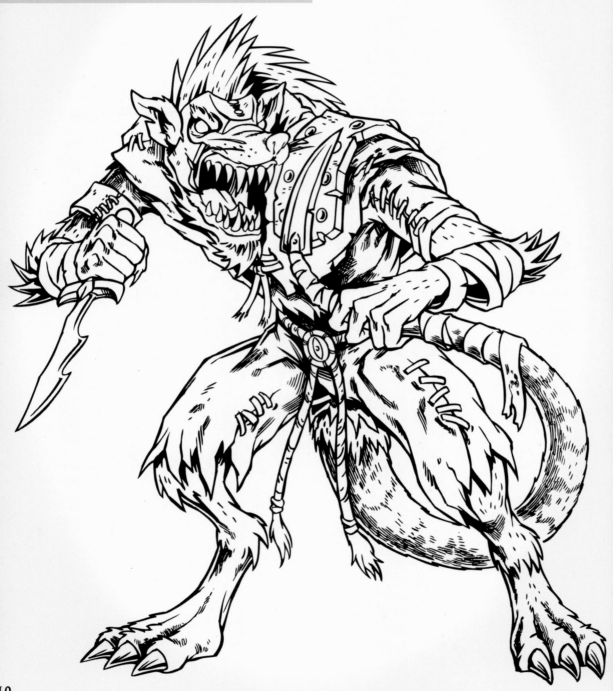

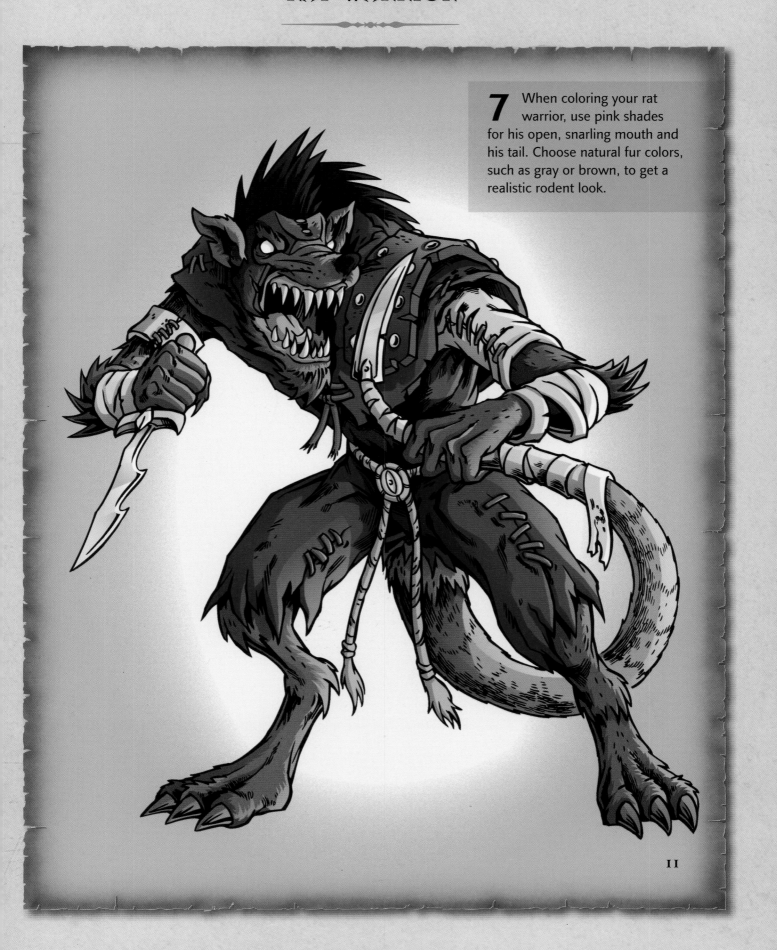

7 When coloring your rat warrior, use pink shades for his open, snarling mouth and his tail. Choose natural fur colors, such as gray or brown, to get a realistic rodent look.

EAGLE GUARD

These formidable winged beasts once lived a solitary existence high up on the mountain peaks. However, as the tide of chaos has spread through the Middle Kingdom, they have begun to soar farther from their home in search of bigger prey and the spoils of war.

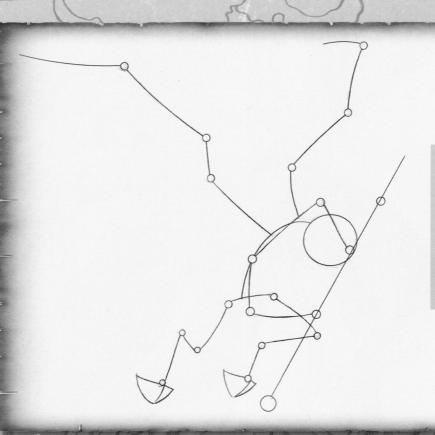

1 Start by drawing your wire frame. Plot all the joints, and draw a line for his staff. The eagle warrior is flying, so draw the wing lines above his body in the air.

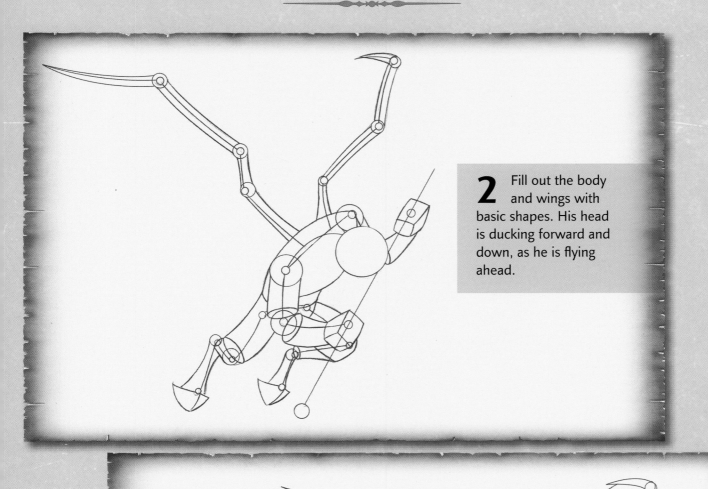

2 Fill out the body and wings with basic shapes. His head is ducking forward and down, as he is flying ahead.

3 As your figure takes shape, remove your working lines and basic shapes. Sketch in the head, beak, wings, and claws. Draw the basic shape of the blade at the end of his staff.

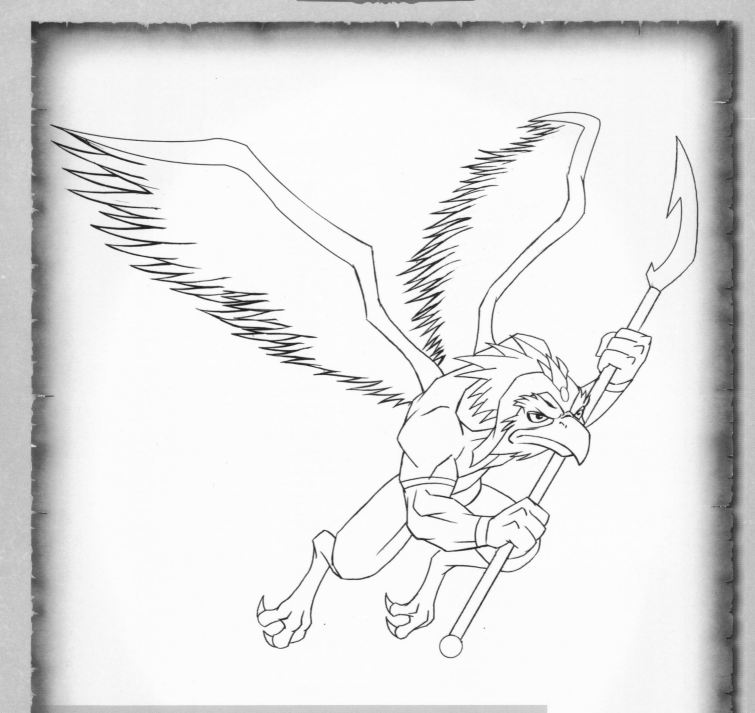

4 Now add detail to your clean pencil drawing. Draw curved, zigzag shapes for the feathers along the outside of the wings. Add his beady eagle eyes, feathery eyebrows, and headdress. Define the shape of his blade, add muscle tone to his body, and give him some razor-sharp claws.

5 Finalize your pencil drawing. To finish the wings, draw layers of feathers that start off small at the base of the back and get larger toward the tip of the wing. Use fine lines to add a feathery effect to the body, arms, and legs. Block in your shaded areas for solid inking.

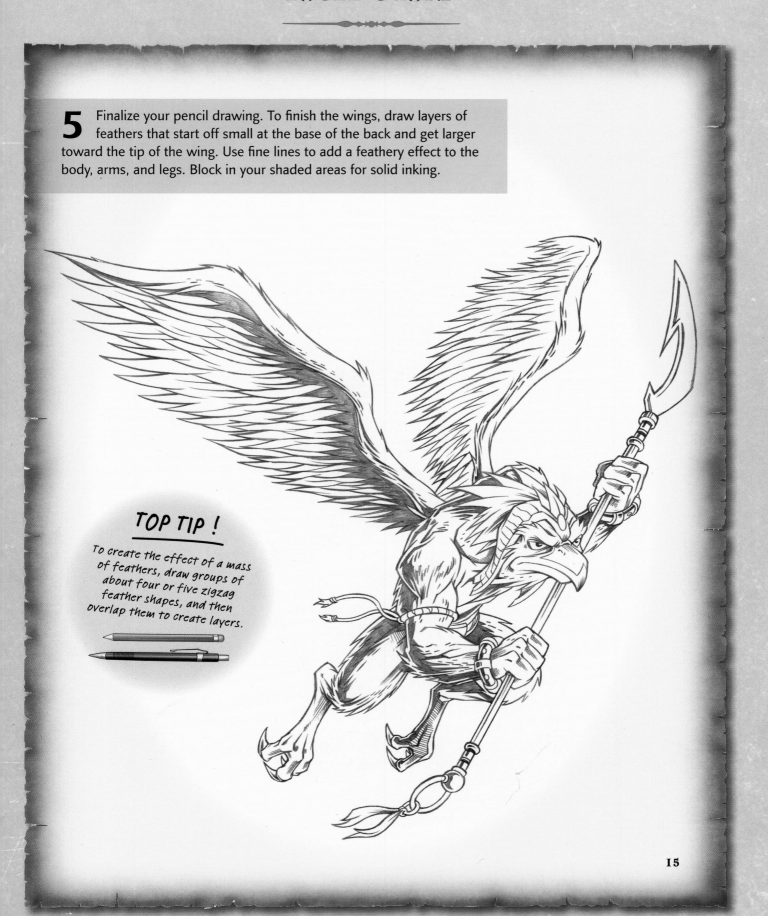

TOP TIP !

To create the effect of a mass of feathers, draw groups of about four or five zigzag feather shapes, and then overlap them to create layers.

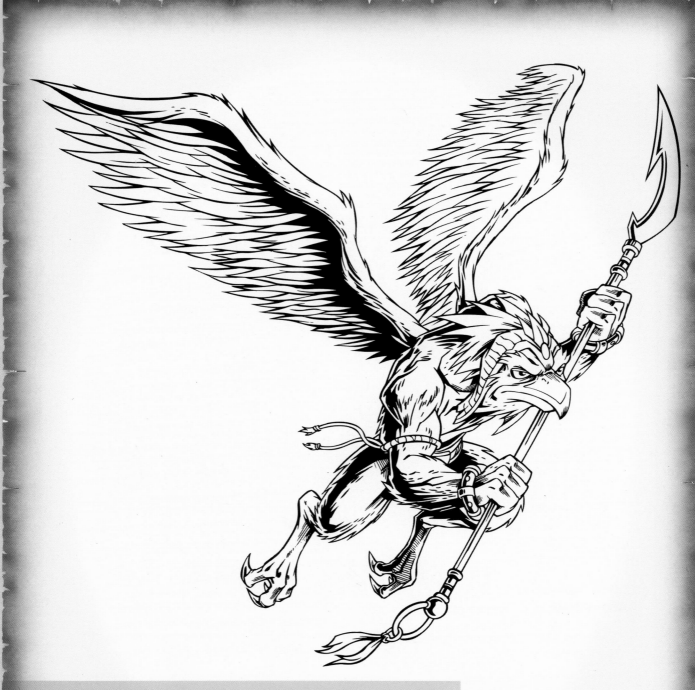

6 Inking all the detail in this character is a tricky task, so take your time. Don't worry if you lose some of the very fine pencil lines, just try to keep as much detail as you can. Areas of solid black add depth, and will help put the drawing in perspective.

EAGLE GUARD

7 When coloring your character, think about the natural coloring of eagles and their markings. Brown and white feathers and a golden beak and feet will make your eagle warrior look authentic.

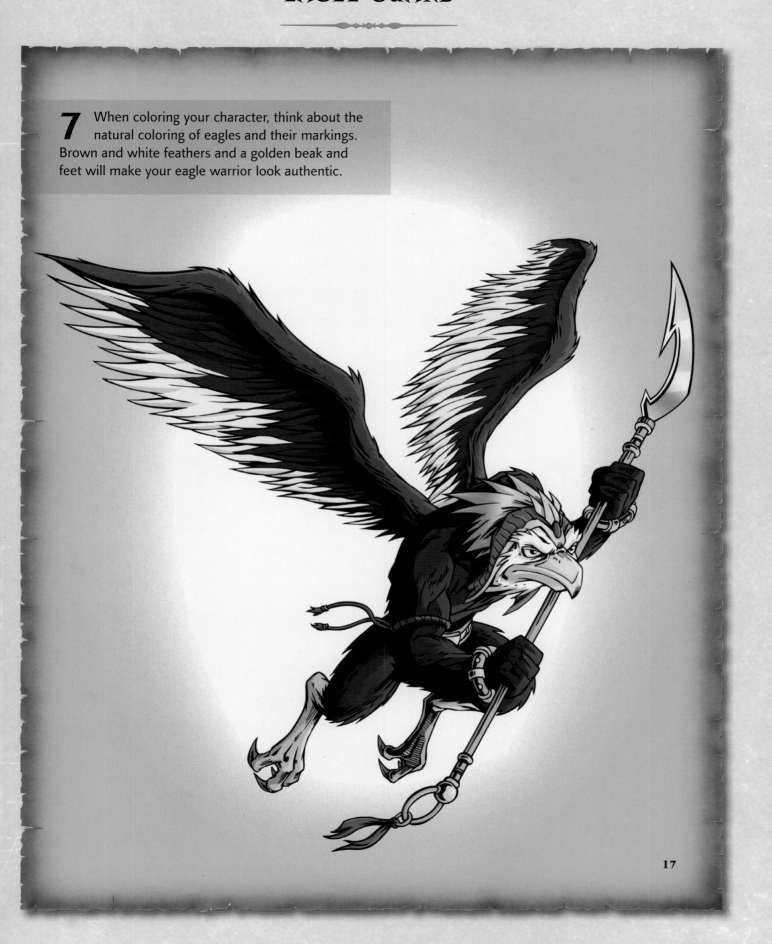

LIZARD MAN

From the swamps to the south
of the Middle Kingdom come
the lizard men. With their
tough hides and lethally quick
reactions, they are a fearsome
addition to the evil army. Any
opponent within tail's reach is
in deadly danger.

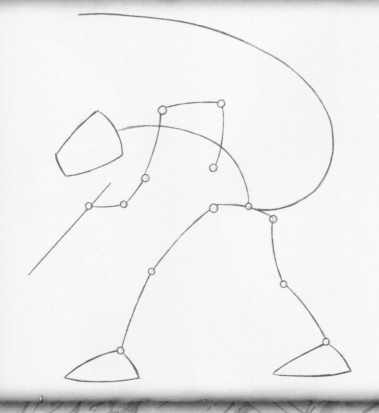

1 Start with your basic frame. The best place to start the lizard man's tail is at the base of the spine, where it joins the hip line.

2 Build the lizard man using basic shapes. This character is drawn from the side.

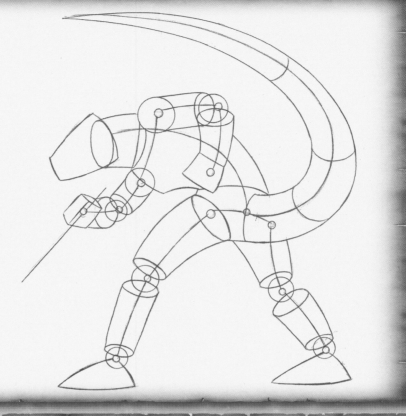

3 Now flesh out your figure and remove your construction shapes as you finalize your lines. Note the shape of the reptilian head and feet, which are longer and more angular than a human's.

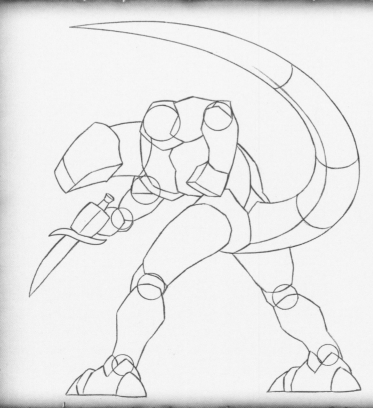

19

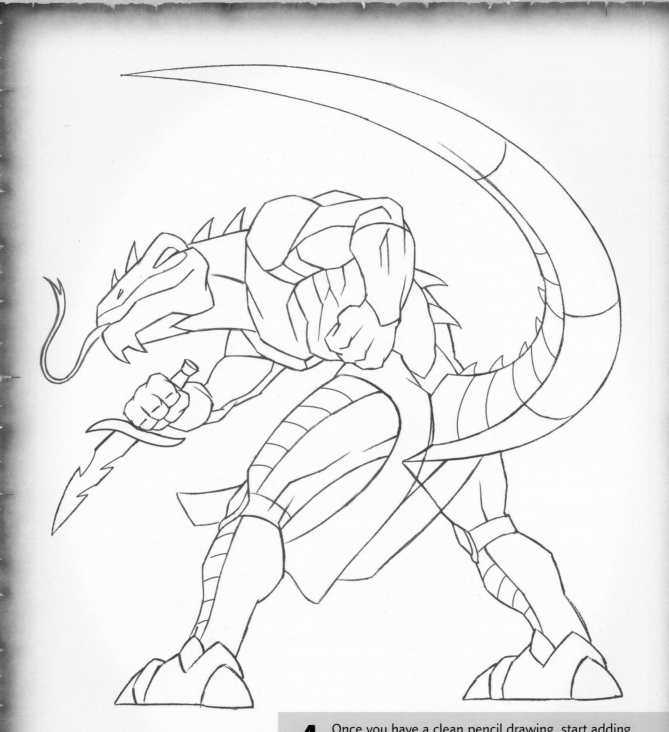

4 Once you have a clean pencil drawing, start adding detail. Begin to draw the reptilian scales, and add some pointed spines running down the length of his back and tail. Draw his tongue, facial features, armor, and clothing.

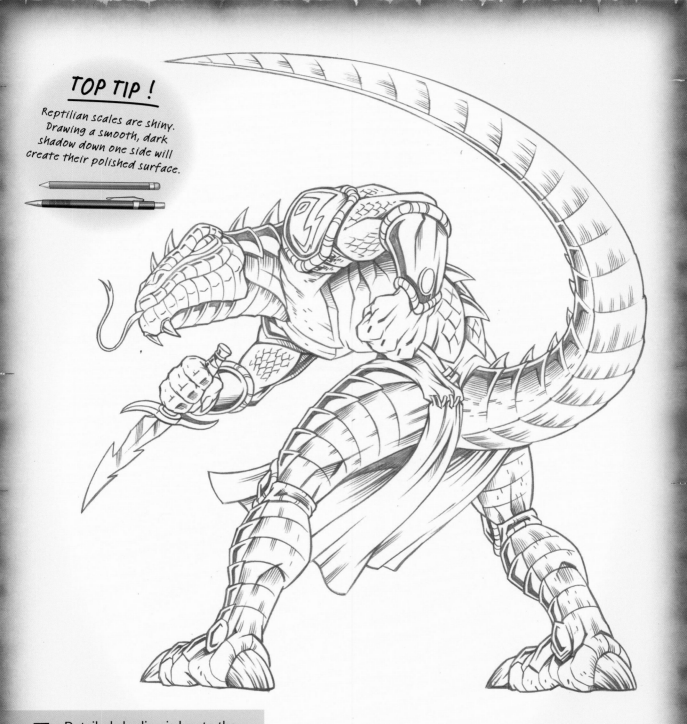

TOP TIP !

Reptilian scales are shiny. Drawing a smooth, dark shadow down one side will create their polished surface.

5 Detailed shading is key to the final pencil stage. Try to define each scale and create a light effect to make the surface look shiny.

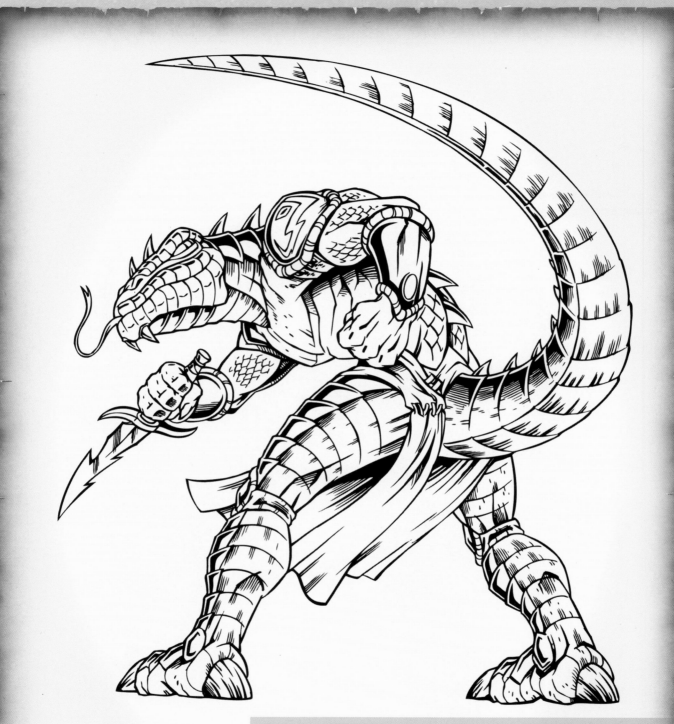

6 When inking your lizard man, use different line thicknesses for different areas on his body. The scales on his face and upper arms require a fine inking technique. A heavier stroke is needed for his armored legs and tail.

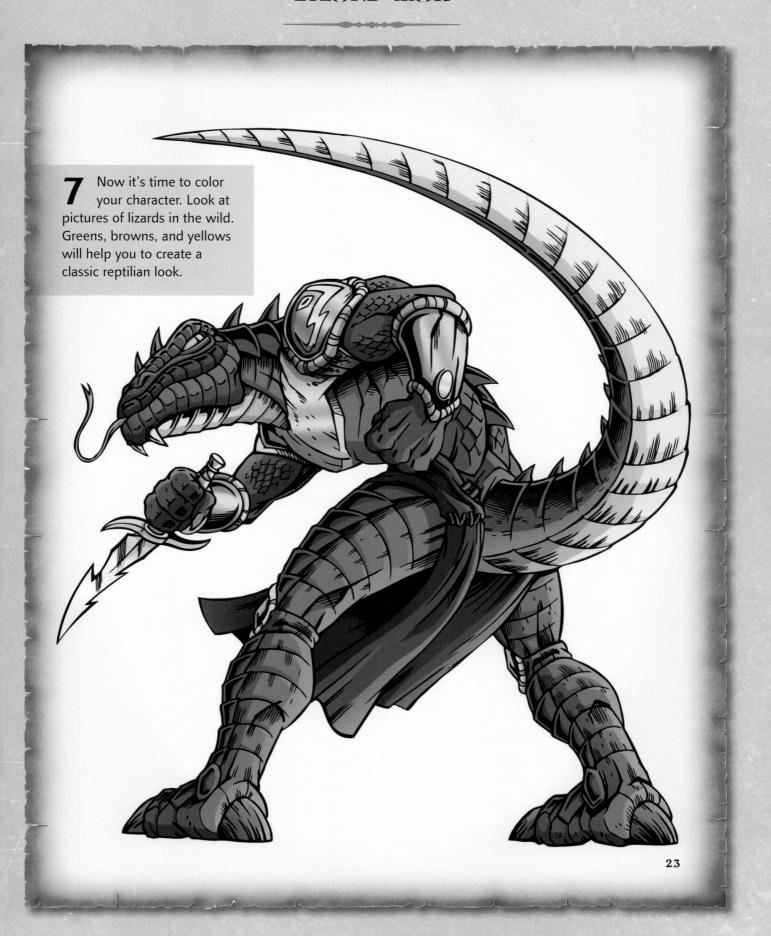

7 Now it's time to color your character. Look at pictures of lizards in the wild. Greens, browns, and yellows will help you to create a classic reptilian look.

The Craggy Mountains

It's time to create a wild landscape for our fierce, half-human creatures. The jagged peaks and smoking volcanoes of this barren mountain landscape reflect the untamed savagery of our beast-men. You would need claws, fangs, and animal cunning to survive in this inhospitable wasteland.

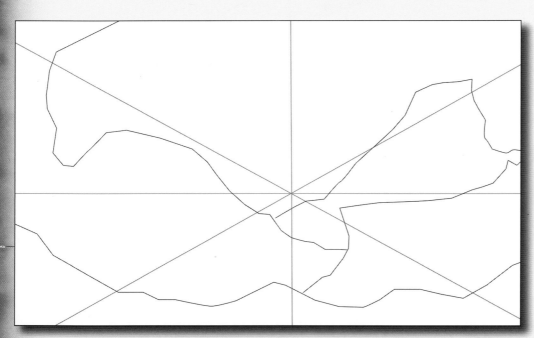

1 Plot out the basic plains of your scene using a central horizon line as a guide for your vanishing point. This is really only there as a guide—perspective is not as essential when drawing irregular shapes such as rocks and mountains.

2 Add some definition to your basic shapes and plot some extra details such as mountain peaks, castles in the background, and fallen warriors in the foreground. Jagged spikes in the landscape and the castle architecture will give the scene a suitably savage look, bringing to mind the teeth and claws of its inhabitants.

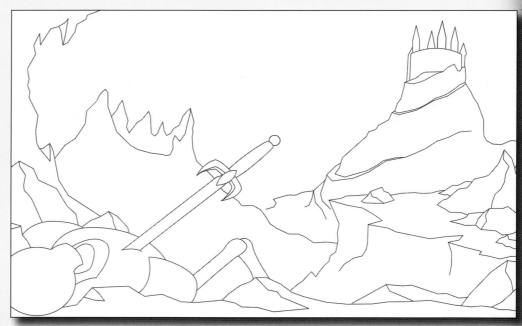

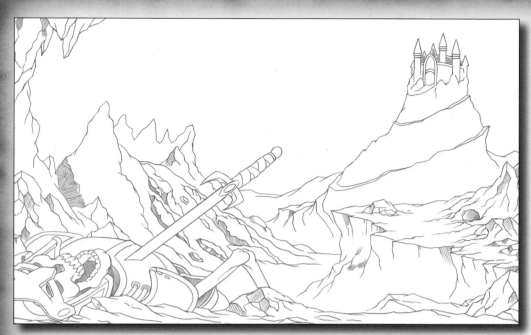

3 Sketch in the craggy textures of the various rock formations, thinking about where surfaces are lumpy and rounded, and where they're broken and sharp-edged. Adding some lava and volcanic smoke to the scene will make it seem extra hot and hostile.

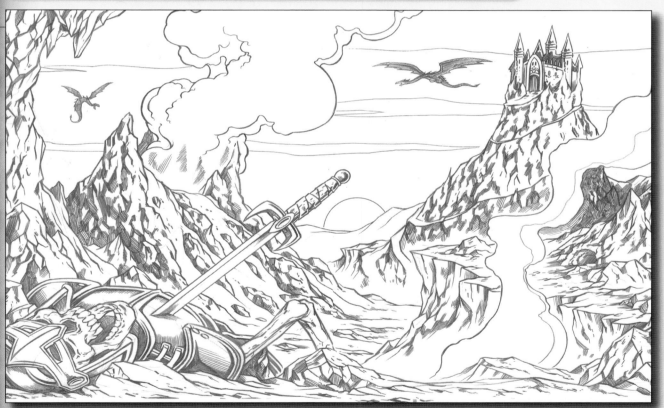

4 As you finalize your drawings, think about light and shading: where will shadows be cast? Add dark patches to places like the bases of the larger rocks and the underside of the armor in the foreground—these are shaded from the setting sun.

25

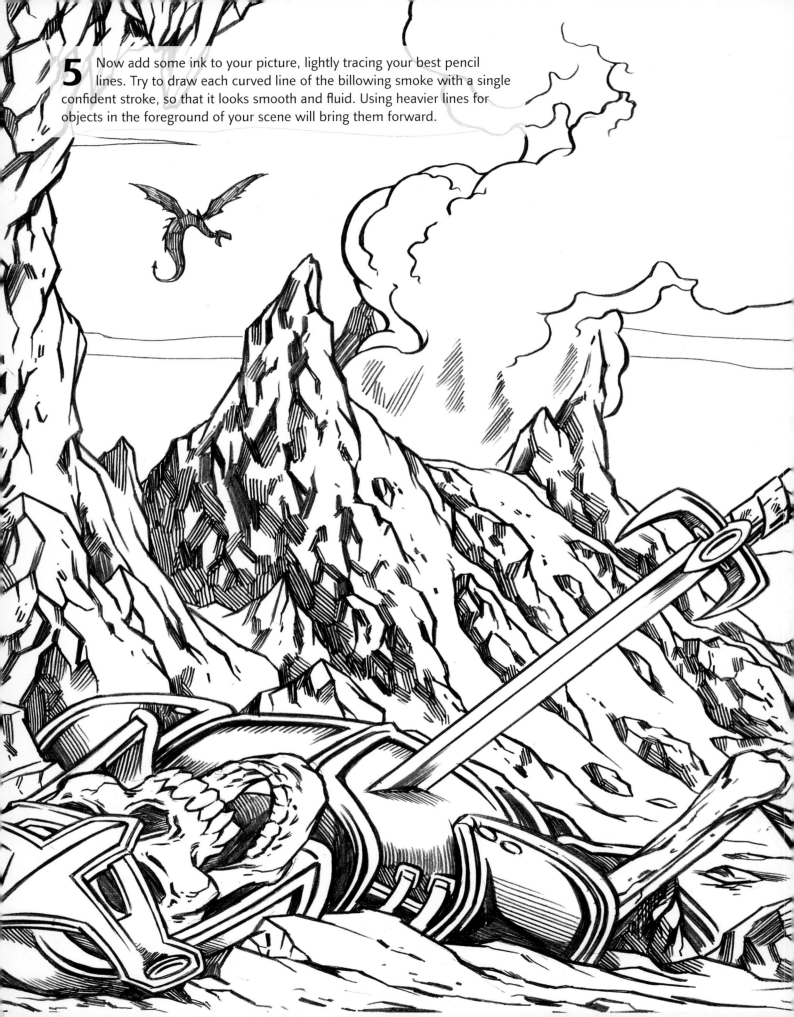

5 Now add some ink to your picture, lightly tracing your best pencil lines. Try to draw each curved line of the billowing smoke with a single confident stroke, so that it looks smooth and fluid. Using heavier lines for objects in the foreground of your scene will bring them forward.

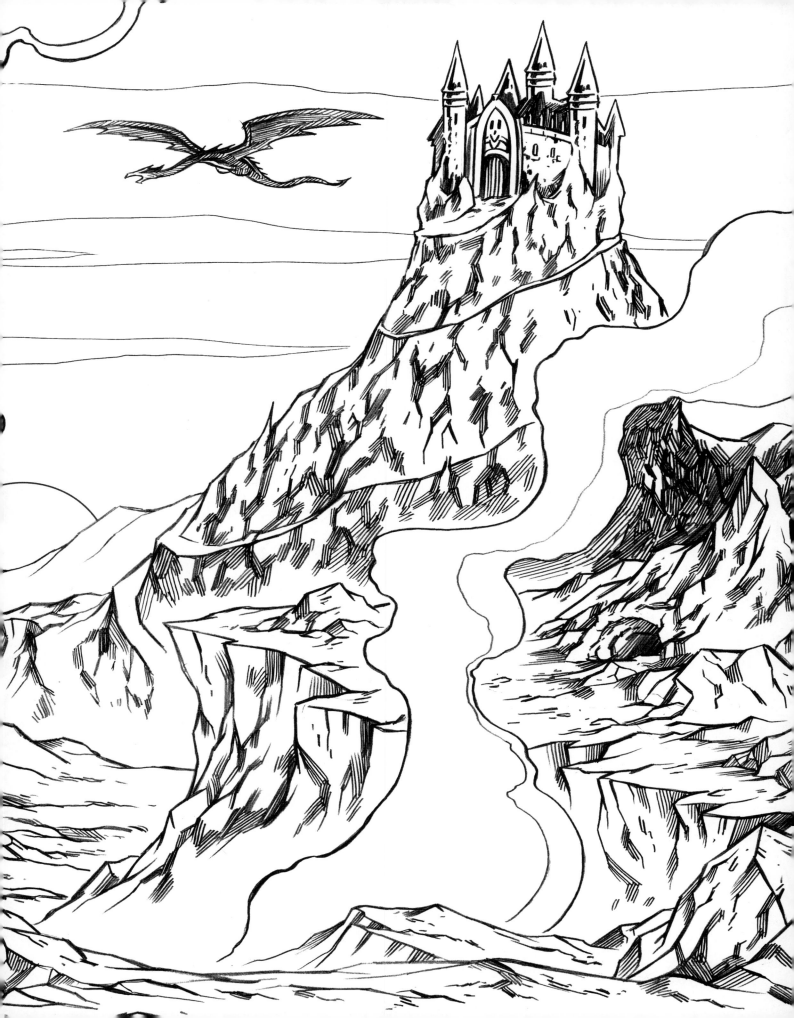

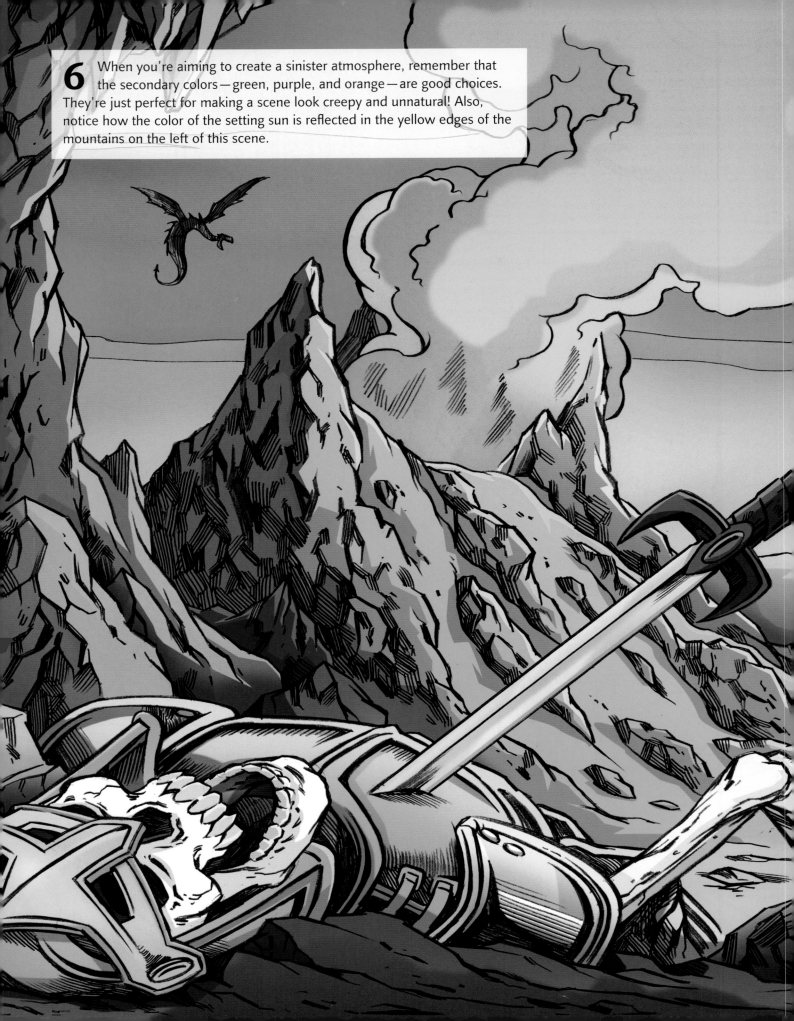

6 When you're aiming to create a sinister atmosphere, remember that the secondary colors—green, purple, and orange—are good choices. They're just perfect for making a scene look creepy and unnatural! Also, notice how the color of the setting sun is reflected in the yellow edges of the mountains on the left of this scene.

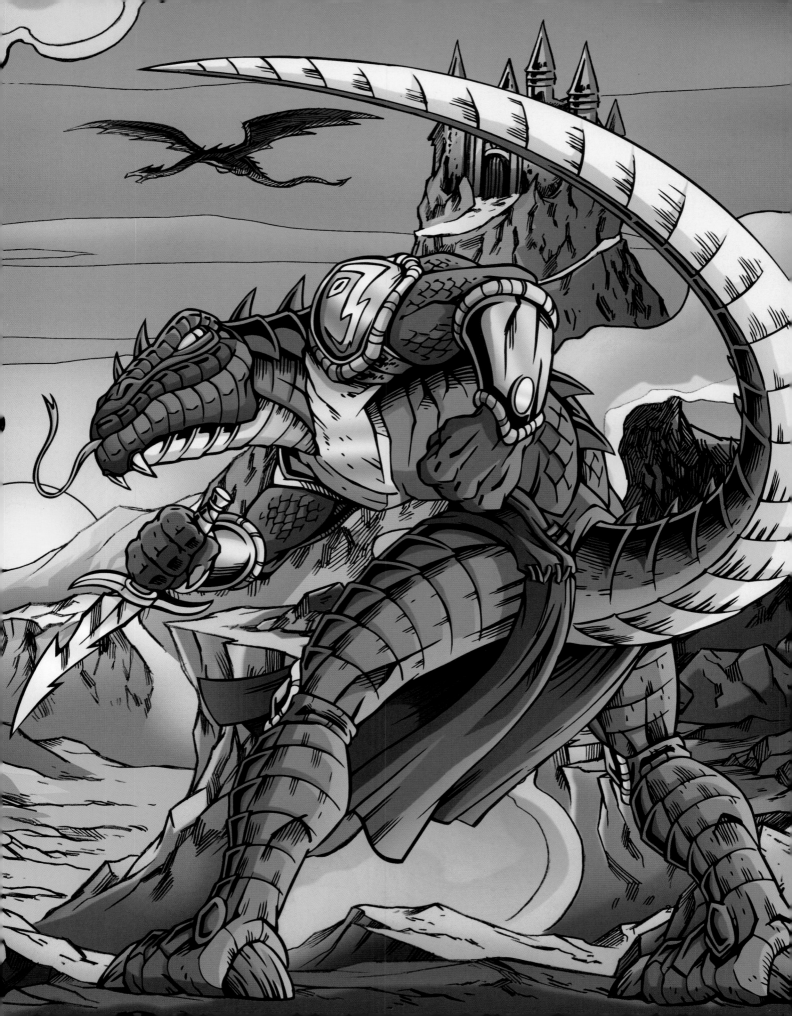

Fur and Claws

When you're drawing a figure with animal characteristics, there's a good chance you'll have to create the impression of fur and draw some sharp claws. Here are some clever tricks to help you get great results.

FUR

Hairy beasts have thousands of individual hairs on their bodies. Obviously it would take far too long to draw every single one, so copy the techniques below to create the impression of a furry covering.

TOP TIP !

Use short pencil strokes to draw clumps of fur, and then layer the clumps to cover your beast's body.

CLAWS AND HORNS

Careful shading in pencil and ink will make your claws and horns look three-dimensional. Think about where the light would be hitting them and add highlights.

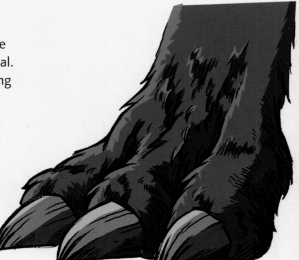

Scales and Feathers

The secret to scales and feathers is to make a little detail look like a lot. By repeating uniform shapes in clumps or patches, you can create the impression that the whole creature is covered.

SCALES AND TAILS

Scales are shiny, hard, and reflective. Make sure your creature's limbs are segmented and neat, and then add shadow to one side to show where the light is falling.

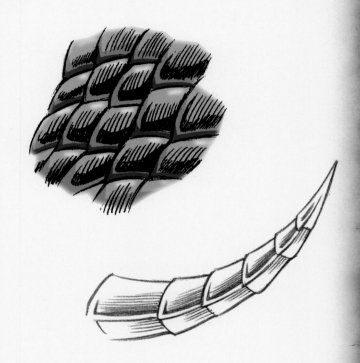

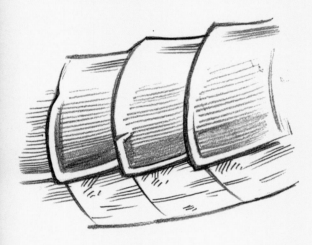

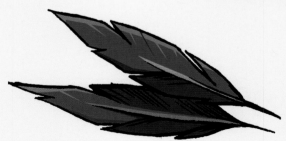

TOP TIP !

Draw feathers in blocks of four or five and then overlap them.

FEATHERS

Feathers, like fur, would take forever if you were to try to draw every single one in detail. Instead, draw a basic almond shape, then repeat and overlap to make a simple pattern that has the same effect as lots and lots of feathers!

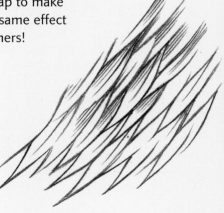

Glossary

ambush attack suddenly and without warning
fluid smooth and flowing
foreground the part of an image nearest to the
 viewer
formidable awesomely powerful
highlights the lightest colored parts of an image
perspective a way of drawing that makes objects
 look three-dimensional
posture the position of someone's body
ravenous very hungry
rodent a type of animal like a rat or mouse
segmented made up of separate parts
solitary alone, or preferring to be alone
spoils stolen goods
tattered torn all over
territory the area protected by a person or animal
texture the way the surface of an object looks
 or feels
torso the middle part of the body
valor courage in battle
vanishing point the place where perspective lines
 appear to come together into a point

Further Reading

Cowan, Finlay. *Drawing and Painting Fantasy Figures: From the Imagination to the Page*. David and Charles, 2004.
Hart, Christopher. *How to Draw Fantasy Characters*. Watson-Guptill Publications, 1999.
Walker, Kevin. *Drawing & Painting Fantasy Beasts: Bring to Life the Creatures and Monsters of Other Relms*. Hauppage, NY: Barron's Educational Series, Inc., 2005.

Index